KATE MOSS

The Style Icon - Redefining
Fashion, Beauty, and Influence

Helen T. Owens

C000064522

All rights reserved. No part of this
publication may be reproduced, distributed,
or transmitted in any form or by any
means, including photocopying, recording,
or other electronic or mechanical methods,
without The Prior written permission of the
publisher, except in the case of brief
quotations embodied in critical reviews
and certain other non-commercial uses
permitted by copyright laws.

Copyright © Helen T. Owens
2023

TABLE OF CONTENT

INTRODUCTION

Few names in the fashion industry have the same profound resonance as Kate Moss. She's not just a supermodel; she's a fashion icon, a trailblazer, and a representation of a period. In addition to captivating the fashion world, her ethereal presence on the runway and in magazine pages has permanently altered the concept of beauty.

The book "Kate Moss: The Style Icon - Redefining Fashion, Beauty, and Influence" delves into the life, career, and significance of this fascinating persona. Kate Moss became the face of '90s fashion with her trademark waif-like physique, captivating eyes, and ability to make couture look effortless. She still has an impact on trends in the twenty-first century.

This book explores Kate's origins, from her modest upbringing in Croydon, England, to her quick ascent to the position of supermodel. We'll learn the techniques

behind her timeless charm, her legendary partnerships with great photographers and designers, and the revolutionary influence of her wardrobe selections.

Kate Moss is a cultural force, not just a model. Her impact may be seen in more ways than just the glossy pages of magazines; it affects how we view style and beauty. We'll look at how she changed accepted norms and allowed for uniqueness and variety in a field that was sometimes criticized for being exclusive.

We'll also lift the veil on this mysterious person's life in these pages, exploring her personal experiences, controversies, and charitable pursuits. You'll learn about her development as a businesswoman, philanthropist, and fashion icon as we trace her journey over the years.

We'll also look at her legacy and enduring impact on the fashion business since she left a lasting impression that still shapes the popular culture, fashion, and beauty industries. The life of Kate Moss is one of inspiration, empowerment, and metamorphosis.

Come along on this fascinating trip through the life and times of Kate Moss, a remarkable person whose lasting effect has truly redefined influence, fashion, and beauty.

CHAPTER 1: EARLY LIFE AND BEGINNING

The name Kate Moss, which would go on to become a byword for elegance and beauty, was born in the modest South London neighborhood of Croydon. She was born on January 16, 1974, into a working-class household, and her unusual charm and unearthly beauty were apparent right away.

Kate had a conventional childhood, growing up in a close-knit family, but she also had a unique spark that made her stand out. She had a unique, dreamlike charm that would eventually enthrall people everywhere, even as a little child. People were drawn to Kate Moss because of something called her magnetic nature, as her parents would later narrate.

Her life took an unfortunate turn while she was only about to enter her teenage years. At the tender age of 14, Storm Model Management founder Sarah Doukas spotted Kate at JFK Airport in New York. This

coincidental meeting would initiate an incredible journey for a girl from Croydon to the top of the fashion industry.

Kate's unique appearance defined her early modeling career. Her waif-like body, standing at only about 5 '7", broke conventions in a world where the norm was tall, statuesque models. This distinctive quality, along with her undeniable charm, would turn her into a brand and transform the fashion business.

1.1 Childhood in Croydon

Kate Moss's tale started in the vibrant and varied South London neighborhood of Croydon. She was born on January 16, 1974, and grew up in this typical yet energetic neighborhood. The foundations of a renowned career were sown in Croydon, a far cry from the world's fashion capitals.

The familiar pleasures and difficulties of growing up, along with the warmth of family, characterized Kate's youth in Croydon. She was the daughter of travel agent Peter Edward Moss and bartender Linda Rosina Shepherd. Raised with her brother Nick by her side, Kate was taught the virtues of perseverance and hard work by her parents.

Even at an early age, Kate's distinct charm and charisma were apparent, even considering Croydon's relative isolation from the glitzy world of fashion. Her captivating personality, which appeared to set her apart

even in her early years, is remembered by friends and relatives.

It was evident that she was not your typical schoolgirl as she attended Riddlesdown Collegiate after attending Ridgeway Primary School. At the age of 14, Kate Moss was recognized at JFK Airport in New York, an event that would forever alter her life and set in motion her incredible adventure.

1.2 Kate's Ascent in the Modeling World

Kate Moss's rise from a regular young girl to a worldwide fashion icon was nothing short of extraordinary. At the age of 14, she was discovered in New York's JFK Airport, setting off on a course that would take her to the pinnacles of the fashion industry.

Kate's distinctive appearance contributed significantly to her early modeling career. In an industry where tall, statuesque models were usually preferred, her waif-like body and relatively modest height for a model—she stands at about 5'7"—attracted initial attention. But it would be precisely this individuality that would serve as her signature and launch her career into the spotlight.

The key to Kate's rise was her partnership with Storm Model Management founder Sarah Doukas, who met her at the airport. Doukas was determined to introduce the young adolescent into the world of fashion because he saw something exceptional in her. She recognized the

possibility of a novel form of beauty that would go against the accepted conventions in the field.

A classic photo shoot for The Face magazine in 1990 was Kate's big break. Photographer Corinne Day shot her in a sequence of unposed, organic poses free of elaborate styling or heavy makeup. As a result of this unvarnished and genuine approach to photography, the "heroin chic" look emerged. In sharp contrast to the glitzy and refined pictures of the past, this look embraced flaws and organic beauty.

Kate Moss shot to prominence and was soon in high demand as a model, appearing in Vogue, Elle, and other high-end fashion magazines. She also appeared on the catwalks for some of the biggest names in fashion, such as Calvin Klein. Her role as a supermodel was cemented by her participation in Calvin Klein's marketing campaigns, especially the renowned Obsession fragrance campaign.

CHAPTER 2: THE MOSS MAGIC UNVEILED

There was something about Kate Moss that defied description; she had a magnetic charm that cut beyond the boundaries of beauty and fashion. She was more than simply a model; she was a mystery, a figurehead, and an emblem of a time. Let's explore the core of what made Kate Moss so enchanting.

1. Kate's Signature Style:

Kate Moss had a distinct sense of style that was effortlessly stylish. She had a remarkable talent for making even the most audacious wardrobe selections seem approachable every day. She wore a combination of high fashion, vintage, and grunge pieces that reflected her style and the eras she was successful in.

The phrase "Kate Moss style" has come to refer to her distinct fusion of rock 'n' roll attitude and boho elegance. An entire generation was affected by her love of vintage tees, leather jackets, and slim jeans. She embodied the '90s cool vibe, which continues to influence fashionistas and designers to this day.

2. The Enigmatic Allure:

Kate had a compelling combination of androgyny and sensuality, strength and vulnerability. Her black, unkempt hair accentuated her adorable eyes, which drew everyone in. She had a certain aura of mystery about her that kept drawing people in.

Her ease and grace in front of the camera were regularly mentioned by photographers. Numerous artists looked up to her because of her ability to portray a wide spectrum of emotions, from sensual to whimsical. With every click of the camera, Kate Moss could change her appearance into a different person, whether it was a

carefree, mischievous smile or a smoky-eyed, seductive glance.

Her adaptability was what made her so magical in the realm of fashion. She could go with ease from glamour to androgyny, from high couture to grunge, all the while projecting an air of genuineness. She was the ultimate muse, always reinventing herself and establishing new trends because of her chameleon-like quality.

2.1 Kate's Signature Style

Kate Moss was a fashion star recognized for her unique and impactful style, not merely a supermodel. Her distinctive style and fashion choices made a lasting impression on the design industry and established trends that still appeal to modern-day fashionistas.

Kate Moss's style was defined by her ability to effortlessly combine seemingly incongruous components. The perfect blend of rock 'n' roll attitude, boho elegance, and retro nostalgia was present. Her ability to make daring and unorthodox wardrobe choices seem approachable and natural was evidence of her natural sense of style.

Her love of slim jeans was a major element of her style. This particular denim design gained popularity thanks in large part to Kate Moss, who made it a wardrobe mainstay. Her slim pants gave her a sleek, contemporary

figure that was popular when paired with form-fitting t-shirts or flowy blouses.

Another defining element of Kate's wardrobe was her leather coats. She carried herself with such grace that she gave her outfits a bit of edge. Whether they were fitted or biker-inspired, her leather jackets came to represent her rebellious yet stylish persona.

Kate Moss stands out from other models thanks to her love of antique and thrift clothing. She had a remarkable talent for incorporating antique pieces into elegant ensembles. Her love of antique apparel and her apparent talent for blending textures and patterns created a look that was both approachable and inspiring.

Her hair, which was frequently left in its naturally unkempt state, went well with her carefree, easygoing appearance. Her messy yet stylishly put-together haircut became a hallmark of her look, which many tried to copy.

Kate Moss's signature style was essentially the synthesis of seemingly incongruous components, giving her an opulent yet grounded, rebellious yet sophisticated appearance. Her impact went well beyond the catwalk, influencing fashion trends and motivating designers to produce collections that perfectly encapsulated her recognizable aesthetic.

2.2 The Enigmatic Allure

Beyond her outstanding physical attributes, Kate Moss had a captivating charm. Her allure was greatly influenced by her mysterious charisma, which also helped to establish her as a cultural and fashion icon.

Kate Moss's distinct combination of strength and vulnerability was the core of her appeal. Her doe-like, wide-set eyes had a way of enthralling everybody who saw them. Whether sultry, enigmatic, or innocent, her gaze had a captivating quality that drew others in and made a lasting impression.

When working with Kate, photographers were frequently in awe of her effortless elegance and comfort in front of the lens. She was a perfect muse for painters since she had the natural ability to portray a wide range of emotions. She could convey sensuality, whimsy, or resistance with the same sincerity and impact.

Kate Moss's androgynous beauty was one of the key elements that defined her mysterious attraction. The distinctions between traditional ideas of male and female attractiveness were blurred by her features. She was able to appeal to a wide variety of audiences and surpass traditional beauty standards because of her androgynous qualities. Her ability to embody both the most glamorous and edgy elements of fashion was evidence of her distinct appeal.

Kate Moss's adaptability was another factor in her appeal. She had a remarkable ability to switch effortlessly between an elegant, high-fashion look and a gritty, streetwise aesthetic. She was able to continuously change herself thanks to her chameleon-like trait, which kept her appearance vibrant and new. Her reputation changed over time by her own experiences and the times.

Furthermore, Kate's genuineness was a key component of her appeal. She never fit into the tight mold that the fashion business forced her to fit into; instead, she was unabashedly herself. Her sincerity struck a chord with a

generation that aspired to reject convention and embrace uniqueness.

CHAPTER 3: THE FASHION MAVERICK

Kate Moss's career in the fashion industry was marked not only by her aesthetic choices but also by her revolutionary influence on the business. She defied expectations, reinterpreted beauty standards, and established trends that would last for decades, earning her reputation as a fashion maverick.

1. Catwalk Queen:

Even though Kate Moss was unusually tall for a model, she became well-known on the global catwalks very fast. She had a captivating runway presence and radiated charisma and confidence that mesmerized both designers and spectators.

Kate established herself as a mainstay at fashion shows, walking for the likes of Marc Jacobs, John Galliano, and

Alexander McQueen. Her maverick attitude was demonstrated by her ability to bring a distinct sense of style and personality to the runway. She did more than just put on the garments; her presence changed them.

Her runway shows were occasions in and of themselves, not only opportunities to display the newest creations. People looked forward to Kate Moss's walks, and her unique ability to make clothes come to life made her a fashion icon.

2. Pioneering Trends:

Kate Moss was a trendsetter in addition to being a model. She was a true maverick because of her sharp sense of style and daring attitude to fashion. Her ability to blend high fashion with vintage items was evident, and fashionistas all over the world frequently copied her looks.

Her most well-known contribution to fashion throughout the 1990s was making the "heroin chic" style popular.

Instead of focusing on glitzy styling and excessive makeup, this approach to photography embraced a natural and unfiltered look. Kate Moss's collaboration with photographer Corinne Day was crucial in creating this trend and expanding the definition of style and beauty.

Her versatility in dressing for many eras was also unmatched. She was a style chameleon who could pass from boho to minimalism, grunge to glam, and anything in between. She was always in demand by designers and fashion firms to represent their collections because of her distinct appeal, which they believed may improve the brand's reputation.

Kate's impact was not limited to the catwalk. Her partnerships with leading designers produced collections that were distinctly her own. Her collaboration with the British fashion brand Topshop, for instance, allowed her to select a line of apparel that complimented her style and quickly gained popularity among shoppers who were interested in fashion.

3.1 Catwalk Queen

The rise of Kate Moss to the position of "Catwalk Queen" was truly amazing. With her height of around 5'7", she defied the conventional norms of model height. Nonetheless, her distinct fusion of charm, self-assurance, and an unfathomable attraction rendered her an alluring presence on the most esteemed runways globally.

When Kate rose to prominence in the 1990s as a highly sought-after model for runway shows, her career on the catwalk took off. Designers saw she had a unique talent for elevating clothes beyond mere articles of clothing. Her mesmerizing presence on the runway gave the creations life and transformed them into engrossing tales of fashion and art.

Kate Moss's assured yet carefree gait was a key component of her success on the catwalk. She redefined what it meant to be a supermodel as she glided down the runway with an effortless ease. Her mysterious charm

was reflected in her motions, which captivated both photographers and audiences.

Kate's runway performances gained depth from her ability to depict a variety of emotions through her facial expressions and body language. She could convey a narrative with each step, whether she was walking the catwalk with a strong confidence or a humorous charm.

Her fashion show performances were more than just modeling engagements; they were occasions. There was a tangible buzz about a runway appearance by Kate Moss. It was about the experience, the spectacle, and the way fashion became art rather than just the clothes.

Designers who had the honor of collaborating with Kate Moss on their collections were fully aware of her potential influence. Her presence enhanced the presentation's enthusiasm and attractiveness in addition to increasing the visibility of their goods. Kate's runway appearances demonstrated how fashion could both enthrall and inspire, going beyond simple route planning.

3.2 Pioneering Trends

Supermodel Kate Moss had a significant impact on the fashion business that went well beyond her position. She was a trailblazer, a maverick who openly questioned accepted notions of beauty, pushed the limits of style, and had a lasting impression on the fashion industry.

The 1990s "heroin chic" style is one of the most recognizable trends linked to Kate Moss. In contrast to the glitzy and elaborately planned fashion photography of the past, this approach marked a radical shift. Rather, it embraced a genuine and unprocessed style that was defined by unkempt hair, little makeup, and a focus on inherent beauty.

Corinne Day, a photographer, was instrumental in creating this trend with her innovative portraits of Kate Moss. The pictures conveyed a more genuine and unadulterated vision of beauty by capturing a feeling of closeness and vulnerability. A generation that aspired to

reject conventional beauty standards and embrace a more real, less polished ideal found resonance in the "heroin chic" appearance.

Kate had an impact that went beyond style. She was largely responsible for the trendiness of slim jeans. Her affinity for these tight-fitting denim pants and her skill at wearing them with ease into a variety of ensembles helped to promote this trend and turned it into a wardrobe staple for many.

Her ability to set trends was demonstrated by her partnership with Calvin Klein, especially in the renowned Obsession fragrance campaign. The advertisement had a significant effect on the fragrance and fashion industries by evoking sensuality and desire. It was evidence of Kate's exceptional talent for arousing feelings and capturing the essence of a period.

Additionally, Kate Moss was a trailblazer in the field of fusing high fashion with antique items, successfully uniting the domains of luxury and thrift. A new

generation of fashion aficionados was inspired to explore and establish their distinctive looks by her daring fashion choices, such as matching vintage jeans with a designer blazer.

Her collaboration with the British fashion store Topshop also produced collections that reflected her flair. Through this partnership, she was able to have a direct impact on the styles and attainable fashion choices of a larger market.

CHAPTER 4: ICONIC COLLABORATIONS

In addition to being a supermodel, Kate Moss served as a creative force, a muse, and a blank canvas for photographers and designers to create their visions. Some of the most famous and memorable moments in the industry were produced by her partnerships with well-known personalities in the fashion and photography industries.

1. Kate and Designers:

There was an unwritten understanding between Kate Moss and fashion designers. She had a natural ability to make their ideas come to life, giving them a distinct appeal that very few other models could equal.

Her partnerships with fashion designers like Vivienne Westwood, Alexander McQueen, and John Galliano

frequently produced runway shows and advertising campaigns that went beyond simple fashion presentations. Kate had a talent for taking the designer's idea and making it uniquely her own. Their collections sprang to life in her presence and became works of art.

Her partnership with designer John Galliano for Christian Dior was one of her most notable partnerships during her career. She donned a dress with a newspaper print that has become legendary from the Spring/Summer 2000 collection. It captured the spirit of the day and is still recognized as a classic example of high fashion.

2. Memorable Photoshoots:

The work that Kate Moss did with photographers was equally important. Her distinct charm and ability to change up her look and feel like a chameleon was brought to life by skilled photographers.

A major influence on Kate's career was Corinne Day, the photographer responsible for the ground-breaking pictures that helped create the "heroin chic" look. "The 3rd Summer of Love," the 1990 photo shoot for The Face magazine, was a pivotal event that thrust Kate and Corinne into the spotlight.

Her collaborations with Mario Testino, Nick Knight, and Patrick Demarchelier, among others, produced an extensive body of work filled with memorable pictures. Kate Moss's personality was reflected in these photoshoots, ranging from casual androgyny to smoldering sensuality.

Kate collaborated on artistic endeavors and fashion campaigns in addition to photography. Her ability to be a creative muse for musicians and artists such as Lucian Freud, Pulp, and Primal Scream demonstrated her flexibility.

4.1 Kate and Designers

A remarkable partnership between Kate Moss with some of the most recognizable fashion designers in the business defined her career. Her natural sense of style and extraordinary ability to realize their dreams made her a style icon for many, leading to a string of iconic partnerships that changed the fashion industry.

Christian Dior and John Galliano:

Throughout Kate's career, her relationship with the renowned British designer John Galliano was one of the most memorable. Their partnership with the esteemed Christian Dior label produced fashion industry firsts. Galliano identified a muse in Kate who could capture the spirit of his designs, and their collaborative efforts on ads and runway shows demonstrated their creative synergy.

One of the best examples is the Christian Dior Spring/Summer 2000 collection. Kate Moss wore the now-famous dress with the newspaper pattern, which became a symbol of luxury fashion. The style captured the spirit of the day and was more than just an item of apparel. When Kate wore the dress, it became iconic because of her effortless confidence.

The Savage Beauty and Alexander McQueen:

The impact of Kate Moss's partnership with visionary designer Alexander McQueen was equally significant. Kate was the ideal medium for McQueen's audacious and cutting-edge creations, as he was well-known for pushing the boundaries of fashion.

Among their most treasured joint efforts was the "Dante" collection for Spring/Summer 1996. Kate Moss, clad in a dress coated in spray paint, appeared suspended in midair, creating an iconic and strange image that perfectly captured McQueen's concept of fashion as art.

Kate was crucial to the success of this collection, which marked a revolution in fashion.

Punk Couture and Vivienne Westwood:

Kate Moss's collaboration with renowned designer Vivienne Westwood served as evidence of her capacity to accept a wide range of fashion looks. Model Kate was discovered by Westwood, who was well-known for her punk-inspired designs, as someone who could easily capture the rebellious essence of her works.

Wearing a corset and fishnet stockings, Kate Moss exuded an edgy and raw sensuality in one of their most memorable collaborations. Westwood's punk couture and Kate's magnetic personality came together to create photos that defied preconceived ideas about what was beautiful and fashionable.

4.2 Memorable Photoshoots

Supermodel Kate Moss's career was shaped by her amazing ability to capture the attention of the camera in addition to her presence on the catwalk. Her partnerships with well-known photographers produced an extensive body of work filled with memorable and famous shots that have permanently altered the fashion and photography industries.

Corinne Day and "Love's Third Summer":

Kate Moss's partnership with photographer Corinne Day was a turning point in her career. Fashion photography underwent a sea change in 1990 with the release of "The 3rd Summer of Love," a picture shoot for The Face magazine. Kate was photographed in these pictures with

very little grooming or cosmetics applied, highlighting her inherent attractiveness.

The "heroin chic" movement that resulted from this picture shoot eschewed the highly polished and glitzy fashion photography of the past in favor of an honest and raw appearance. It spoke to a generation that aspired to accept a more real, less manufactured definition of beauty.

Patrick Demarchelier and Mario Testino:

Working with renowned photographers such as Mario Testino and Patrick Demarchelier, Kate Moss produced a series of striking pictures. Her versatility and the spectrum of emotions she could portray through her expressions were demonstrated in these photo shoots.

The photographs gained depth and genuineness from Kate's ability to portray emotions, whether she was emulating humor, sensuality, or a hint of androgyny.

Whether seductive or playful, her gaze had a remarkable ability to captivate onlookers and make an impression.

Her collaborations with Mario Testino in particular resulted in a collection of pictures that were glitzy and elegant. Because of her natural charisma and self-assurance in front of the camera, Kate was Testino's ideal subject, and their partnerships produced some of the most striking fashion photography ever.

Nick Knight and Innovative Initiatives:

Beyond standard picture assignments, Kate Moss and photographer Nick Knight collaborated on other projects. Their collaborations frequently delved into artistic endeavors. Knight, who is renowned for his avant-garde approach to fashion photography, recognized Kate as a subject capable of pushing the limits of the genre.

Working together, they produced avant-garde images and experimental fashion films that highlighted Kate's

openness to embracing new artistic and technological advancements. These initiatives further cemented Kate's reputation as an industry transformation by fusing fashion, art, and technology.

CHAPTER 5: THE MOSS EFFECT

Kate Moss's impact goes well beyond her career as a supermodel. She is a phenomenon in culture, a representation of a time, and a force behind change in the beauty and fashion industries. The phrase "The Moss Effect" perfectly captures the enormous influence she has had on the field and popular culture.

1. Redefining Beauty Standards:

Kate Moss's career signaled a change in the expectations of beauty. Her presence defied convention in a profession where towering, statuesque models were the norm. Her androgynous charm and waif-like physique revolutionized the notion of beauty. She gave proof that being original and genuine could have greater influence than following conventional wisdom.

She represented the "heroin chic" movement of the 1990s, which embraced an unprocessed and more organic form of beauty. It was a radical departure from the glossy, well-composed pictures that had dominated fashion photography, as it celebrated flaws. Beyond the catwalk, Kate Moss had a profound effect on beauty ideals that changed society and culture.

2. Style-Related Influence:

Kate Moss's look became well-known and associated with a carefree fusion of rock 'n' roll attitude and boho elegance. Her wardrobe selections, which included leather jackets, vintage items, and slim jeans, established trends that are still popular with fashionistas. Her fashion choices expressed who she was as a person and helped to define the trends for the 1990s and beyond.

Designers and brands acknowledged her exceptional capacity to enhance their collections. Her partnerships produced items with her distinctive mark, elevating her to prominence in the fashion industry. Kate Moss turned

the clothing into works of art in addition to simply wearing it.

3. Cultural and Artistic Impact:

Kate Moss has an impact on music, art, and popular culture in addition to fashion. She served as a model for many musicians, including well-known groups like Primal Scream and Pulp. Her unique presence in record covers and music videos gave their artistic expressions a further dose of mystery and charm.

Kate Moss further cemented her image as a living work of art when she became the subject of famous painters such as Lucian Freud. Her partnerships with photographers resulted in innovative artistic endeavors that integrated fashion, technology, and visual arts.

5.1 Redefining Beauty Standards

It is impossible to overestimate Kate Moss's influence on the fashion industry and the idea of beauty. She ushered in a period of revolution and honesty by questioning and redefining conventional criteria of beauty.

When Kate first came to prominence in the late 1980s and early 1990s, the modeling world was mostly in favor of tall, statuesque women who fit a certain physical mold. Kate Moss, who is about five feet seven inches tall, disregarded these expectations. Her androgynous charm, thin build, and tiny stature gave her a waif-like appearance that seemed out of place in a field that had long upheld a strict definition of beauty.

But it was exactly this unique and androgynous beauty that made Kate Moss unique. Anyone who saw her could not help but be captivated by her distinct charm and

charisma, which went beyond the traditional supermodel's physical characteristics.

Kate's look disproved the idea that beauty had to fit into a predetermined range of dimensions or characteristics. Her rise to prominence signaled a dramatic change in the industry by proving that beauty could come in many forms. From her slightly crooked teeth to her little stature, her "imperfections" became her signature, and she chose to embrace rather than hide them.

With Kate Moss at its center, the "heroin chic" movement highlighted a genuine and unfiltered approach to fashion photography. This fashion stood in sharp contrast to the overly Photoshopped and glossy photos that had previously dominated the business, favoring natural beauty, messy hair, and minimum makeup. Kate Moss's "heroin chic" style became iconic and resonated with a generation that valued an unpolished, more real definition of beauty.

Her impact was not limited to style. She turned into a beloved cultural icon of uniqueness and sincerity. Kate Moss's accomplishments showed that being beautiful was about accepting one's individuality and being unabashedly oneself, rather than being restricted to certain physical characteristics. She challenged conventional notions of beauty and encouraged others to value uniqueness and sincerity.

5.2 Cultural Impact

The influence of Kate Moss goes well beyond the fields of beauty and fashion. She is a cultural figure who has had a profound impact on society as a whole.

1. Pop Culture and Music:

One of Kate Moss's most enduring cultural legacies is her connection to music. Many musicians and bands, such as Pulp, Primal Scream, and The White Stripes, looked up to her as their inspiration. Her appearance on album covers and music videos gave their artistic expressions a touch more mystery and appeal.

Her partnership with The White Stripes stands out as one of the most notable instances of her musical influence on culture. Renowned director David LaChapelle, who helmed the music video for their song "I Just Don't Know What to Do with Myself," featured her. Her seductive and alluring dance in the music video gave the

song a whole new meaning and created a cultural phenomenon that will never be forgotten.

2. Influence of Art:

Kate Moss has had an equally big impact on the art world. Kate was the subject of a series of paintings by renowned British painter Lucian Freud, which perfectly caught her distinct aura and beauty. Her influence as a fashion icon and a topic of creative curiosity are both demonstrated by these portraits.

In addition, her partnerships with photographers like Nick Knight resulted in innovative artistic endeavors that went beyond fashion photography. Through the fusion of technology, fashion, and visual arts, these projects gave rise to a new phase of artistic inquiry, which Kate Moss was instrumental in influencing.

3. An Era's Icon:

Kate Moss is a symbol of a whole pop culture era as well as a supermodel. Her appearance marks the transition from the refined and glitzy aesthetic of earlier decades to the unpolished and true-to-form style of the 1990s. She personified the "heroin chic" movement, which defined a time when people aimed for a more real, less manufactured definition of beauty.

She turned become a global representation of individualism and honesty, showing everyone that real beauty comes from being unabashedly oneself and embracing one's special traits. Her cultural influence extends beyond aesthetics and style; it is evidence of the strength of uniqueness and self-expression.

CHAPTER 6: LIFE IN THE SPOTLIGHT

Since her debut in the fashion industry, Kate Moss's life has been intricately linked to the limelight. A key component of her amazing career has been her path through celebrity and the difficulties of constantly being in the public glare.

1. The Media Frenzy and Early Stardom:

Kate Moss garnered exceptional attention and media interest from the beginning of her modeling career. She became well-known right away thanks to her striking appearance, unusual style, and special charm. Her captivating presence charmed both the public and media outlets.

Her notoriety increased as she moved into the "supermodel" category. Her picture adorned billboards, magazine covers, and advertising campaigns. She came under constant scrutiny, with tabloids and paparazzi

frequently deconstructing her life. She became the media's sweetheart due to her mysterious charm and indisputable brilliance.

2. Disputations and Scandals:

Kate Moss has had her fair share of controversy during her public life. She was involved in a well-publicized scandal in 2005 related to drug charges. A flurry of media interest was generated when her difficulties with substance misuse were made public. She persevered through this trying time and made a successful recovery to rejoin the fashion industry.

Following the scandal, Kate Moss's career took a turn for the better and she became even more successful. Her ability to persevere in the face of difficulty and maintain her prominence in the fashion industry was indicative of her lasting impact and the public's attraction to her.

3. Private and Individual Development:

Kate Moss has struggled to strike a balance in her professional life between her need for seclusion and her public presence. She became more protective of her family and circumspect about her personal life as she grew older and changed. Her astute handling of the spotlight is evident in her ability to preserve her privacy while becoming a significant figure in the fashion business.

She has shared more details about her life and experiences in the past few years, giving readers an inside look at her style, path, and difficulties. She has been able to establish a more intimate connection with her audience because of her newly discovered openness.

4. A Durable Heritage:

Kate Moss's life in the spotlight has been an intense journey filled with scrutiny, notoriety, and personal development. Her transformation from a young model to a style icon is evidence of her tenacity and timeless appeal. Beyond her professional life, Kate Moss has

become a symbol of genuineness, uniqueness, and the ability to challenge conventional notions of beauty.

Her public existence, with all of its highs and lows, has irrevocably changed popular culture and the fashion business. In addition to being a supermodel, Kate Moss is a living legend, a constant presence, and a representation of the transforming "Moss Effect" that continues to have an impact on people all over the world.

6.1 Personal Life and Relationships

Although a lot of attention has been paid to Kate Moss's work as a supermodel and cultural icon, her personal life and romances have also piqued interest.

1. Family and Early Years:

Born in Croydon, England, Kate Moss grew up in a typical household. Her ideals and character were greatly influenced by her family. Kate's mother, Linda Rosina Shepherd, worked as a bartender, while her father, Peter Moss, was a travel agent. Kate benefited from her family's warmth and love as she was growing up, which enabled her to successfully negotiate the challenges of the fashion industry.

Kate's family continued to play a crucial role in her life even as her career took off. Amid the chaos of fame,

their close-knit relationship offered stability and a sense of foundation.

2. Intimate Partnerships:

Kate Moss has received a great deal of media attention over her career due to her associations with several prominent love engagements.

She was in a famous relationship with actor Johnny Depp. Due to their similar bohemian style and mysterious identities, the two were regarded as one of the "It" couples of the 1990s. Their widely reported romance heightened Kate's attraction and mystique.

Later, she was in a turbulent but ultimately transformational relationship with Pete Doherty, a musician. There were highs and lows throughout their union, and the media watched their trip with great interest. It was a time in her life when she faced both emotional and professional setbacks.

3. Maternity and Individual Development:

Lila Grace, Kate Moss's daughter, was born in 2002 after she and magazine editor Jefferson Hack got married. A major turning point in her life was becoming a mother, which affected her priorities and encouraged personal development.

Rather than taking away from her profession, becoming a mother gave her a new dimension to her identity. She became a symbol of contemporary parenting by juggling her career and her parental commitments. Her capacity to move between various professions was evidence of her adaptability and perseverance.

4. Individuality and Development:

Throughout her career, Kate Moss has always maintained a certain amount of discretion, particularly when it comes to her personal life. Her desire to shield her loved ones from the severe scrutiny that comes with

fame is reflected in her cautious approach to her relationships and family life.

She has shared insights into her path and grown more forthcoming about her experiences and difficulties as she has matured. A greater comprehension of her character and the challenges of living in the spotlight is provided by her personal development and the insights she has shared.

6.2 Controversies and Triumphs

Throughout her career, Kate Moss has seen both noteworthy setbacks and incredible victories, all of which have added to her long reputation as a cultural icon.

1. Fashion Industry Triumphs:

Kate Moss has achieved great success in the fashion sector. At the tender age of 14, she made her stage debut and immediately became well-known for her unusual and unique attractiveness. Her influence on fashion photography, marketing, and the runway altered industry norms and pushed the limits of style.

Her partnerships with well-known designers like Alexander McQueen and John Galliano produced some of the most famous moments in fashion history. She rose to prominence as the face of major fashion houses, representing a time of uniqueness and sincerity. She

distinguished herself as a supermodel and fashion trailblazer with her ability to bring a distinct charm and transformational power to the runway and campaigns.

2. Substance Scandal and Return:

Kate Moss was involved in a high-profile controversy in 2005 related to drug claims. Her career was negatively impacted by the disclosure of her difficulties with substance misuse, which attracted significant media attention. Several advertising contracts were withdrawn from her, and the incident might have destroyed her career.

But it was precisely during this trying time that Kate Moss showed her strength of character. Rather than give in to the uproar, she pulled off an incredible recovery. Her capacity to bounce back from misfortune and relaunch her career was a testament to both her ongoing impact and the public's interest in her.

3. Individual Development and Metamorphosis:

Kate Moss's journey has included both personal development and transformation in addition to professional achievements. A major turning point in her life was becoming a mother, which affected her priorities and encouraged personal development. Her identity was further enhanced and her standing as a modern icon was cemented by her ability to manage her job and motherhood.

Kate Moss has been sharing more of her experiences in the past few years, sharing details about her personal growth and the challenges of being a celebrity. She has been able to share her experiences and lessons learned with her audience and establish a more personal connection because of her newly discovered openness.

CHAPTER 7: THE LATER YEARS

Even though Kate Moss is still a major player in the fashion industry, her later years are distinguished by a combination of timeless style, personal development, and a changing position within the sector.

1. Persistent Impact:

The fashion industry has not been the same since Kate Moss's time. Fashion fans are still inspired by her style, which is defined by a distinctive fusion of rock 'n' roll attitude and boho elegance. Her partnerships with businesses and designers continue to produce things that are distinctly her own.

Her major partnership with British fashion brand Topshop came later in the year. She had great success with her collections, which featured her flair. Through

this collaboration, she was able to have a direct impact on the styles and attainable fashion choices of a larger audience.

2. Adding to Her Collection:

Kate Moss has added more endeavors outside of modeling to her resume in her later years. She has looked into design prospects and contributed her knowledge to perfumes and apparel lines. Her keen sense of marketability and elegance has made her an astute businesswoman in the fashion industry.

3. Mentoring Others:

Kate Moss, a seasoned veteran of the fashion industry, has assumed the role of an advisor to upcoming models. She imparts wisdom and expertise to the younger generation while providing direction and encouragement. Her passion to give back to the profession that has impacted her career is evident in her role as a mentor.

4. Acknowledging Her Genuineness:

Kate Moss has accepted her true self even more in her mature years. She now shares more details about her path and is more forthcoming about her struggles and experiences. She has been able to establish a more intimate connection with her audience because of her newly discovered openness.

Kate Moss's later years are a testament to her continuing influence, development as a person, and changing roles in the fashion business. She continues to be an inspiration to people who respect her long career and influence, a symbol of genuineness and individuality, and a living example of the transformational potential of keeping true to oneself. Beyond simply being a style icon, Kate Moss is a living legend whose influence is still felt in the fashion industry and beyond.

7.1 Kate Moss In the 21st Century

Throughout her multi-decade career, Kate Moss has maintained a strong influence in the twenty-first century. She carried on redefining influence, fashion, and beauty as the new millennium dawned.

1. Icon of Enduring Style:

In the twenty-first century, Kate Moss's reputation as a style icon has only become stronger. Fashion fans are still inspired by her distinctive fusion of rock 'n' roll attitude and bohemian grace. She maintains her signature style while deftly navigating the shifting fashion trends.

Her impact goes beyond what she does on the catwalk. Her fashion selections continue to set trends and captivate the attention of the fashion industry, and her partnerships with designers and businesses produce pieces that bear her distinctive imprint.

2. Broadening Perspectives:

Kate Moss broadened her interests in the twenty-first century to encompass a variety of endeavors outside modeling. She leaped design, contributing her artistic vision to perfumes and apparel lines. She became a shrewd businesswoman in the fashion industry by combining her sense of style with marketability.

3. Mentoring and Contribution:

Kate Moss, an established name in the fashion world, has accepted the responsibility of serving as a mentor to upcoming models. She mentors and supports the next generation by imparting her vast expertise and experience. Her passion for giving back to a field that has been essential to her career is evident in her mentorship.

4 Accepting Genuineness:

In the twenty-first century, Kate Moss has become increasingly vocal about her appreciation of transparency and sincerity. She has provided insights into her journey and been more open about her experiences and difficulties. She is now able to establish a more intimate and personal connection with her audience because of her increased transparency.

The 21st century Kate Moss is proof of her continuing influence, her capacity to remain real and relevant, and her changing responsibilities in the fashion business. She is more than simply a supermodel; she is a living legend whose influence extends outside the fashion industry, impacting 21st-century culture and fashion. The epitome of elegance, genuineness, and the "Moss Effect" that has shaped and redefined the worlds of beauty and fashion is Kate Moss.

7.2 Philanthropy and Business Ventures

The influence of Kate Moss goes beyond beauty and fashion. She has aggressively pursued charitable causes and launched prosperous businesses that highlight her wide range of skills.

1. Charitable Projects:

Kate Moss has supported numerous philanthropic initiatives by using her influence and platform. Her dedication to charitable giving is evidence of her desire to change the world for the better.

Among her many noteworthy charitable endeavors is her participation in the Red Nose Day initiative. She worked on a unique photo session for Red Nose Day, a charity event that raises money for impoverished regions in the UK and Africa, with renowned fashion photographer Rankin. Her support of this cause showed how dedicated she was to using her power to advance societal progress.

2. Commercial Activities:

Kate Moss has pursued commercial endeavors that highlight her inventiveness and drive in addition to her modeling profession. Her commercial endeavors are a testament to her multifaceted abilities and capacity to change with the fashion and beauty industries.

She is well-known for her business partnerships, one of which is with British clothing company Topshop. She contributed her distinct flair to several fashion lines, all of which were wildly successful. Through these collections, she was able to have a direct impact on the styles and attainable fashion choices of a larger audience.

In addition, Kate Moss has developed a range of fragrances that reflect her unique sense of style and persona. Both her ardent followers and the fashion industry have praised her scents.

3. Supporting Others and Developing Them:

Kate Moss's entry into the world of business and philanthropy is evidence of her dedication to uplifting others and contributing to society. Her business endeavors demonstrate her capacity to mold and broaden her career, while her charitable endeavors are in line with her desire to use her influence for the greater good.

CHAPTER 8: LEGACY AND INFLUENCE

Kate Moss has left a lasting and significant legacy in the fashion industry and beyond. Her influence has surpassed that of a conventional supermodel, making a lasting impression on both the public culture and the industry.

1. Redefinishing Style and Beauty:

In the world of fashion, Kate Moss altered conventional beauty standards. Her unusual and androgynous beauty defied the industry's customary standards and demonstrated the variety of shapes that beauty may take. Her "heroin chic" aesthetic distinguished itself from the overly Photoshopped and glitzy pictures that had dominated the fashion industry by embracing a genuine and unprocessed approach to fashion photography. This

change affected how people generally saw style and beauty.

2. Forming a Period:

Kate Moss came to represent the 1990s, a decade characterized by a shift toward individualism, sincerity, and acceptance of flaws. The "Moss Effect" highlighted actual, unadulterated beauty and is still relevant to people who value a more authentic, unrefined form of style.

3. A Designer's Muse:

Kate Moss was more than just a model; she served as an inspiration for well-known fashion designers including Vivienne Westwood, Alexander McQueen, and John Galliano. Fashion history was revolutionized by her unmatched ability to realize their dreams and her natural sense of style. She was a crucial component of some of the most iconic moments in the business thanks to her influence on the runway and in fashion advertisements.

4. A Phenomenon of Culture:

Kate Moss had a significant influence on popular culture, music, and art. She served as a model for well-known musicians, a subject for renowned artists such as Lucian Freud, and a representation of a time when people yearned for uniqueness and authenticity. Her cultural relevance was further enhanced by her appearances in music videos, record covers, and other artistic endeavors.

5. Business Ventures and Philanthropy:

In addition to her modeling career, Kate Moss pursued prosperous commercial endeavors and charitable endeavors, demonstrating her multifarious abilities and her dedication to inspiring others and contributing back to society.

6. Lasting Impact:

Despite decades of changes in the fashion and cosmetics industries, Kate Moss's influence has remained strong. Her everlasting influence is evident in her ageless style and in the way she keeps evolving and adapting to changing trends.

8.1 Kate Moss's Ongoing Legacy

The impact of Kate Moss on the beauty and fashion industries has endured over time. Her legacy is still growing and changing, inspiring new generations and having a lasting impression on the business.

1. Creating the Environment for Modern Fashion:

Kate Moss's ability to adapt and maintain her classic style is demonstrated by her continued influence in the fashion industry. Fashion fans are still inspired by her distinctive fusion of rock 'n' roll attitude and bohemian grace. Her distinctive look, which is characterized by her uniqueness and genuineness, continues to serve as a benchmark for fashion designers, models, and aficionados.

Her partnerships with well-known companies and designers continue to yield collections that are distinctly her own. Her capacity to remain current in a constantly

evolving fashion industry is reflected in her influence on the runway, in fashion advertising, and the design world.

2. An Advisor to Emerging Skill:

A new generation of models is being mentored by Kate Moss. Her extensive knowledge base and life experiences offer priceless advice and assistance. She helps up-and-coming talent in the fashion business grow and develop by sharing her knowledge and views.

3. Increasing Commercial Efforts:

Kate Moss has dabbled in business ventures that showcase her entrepreneurial flair in addition to her modeling profession. In addition to showcasing her inventiveness, her fragrances, fashion lines, and other business endeavors show how she can mold and expand her career.

4. Dedication to Philanthropy:

Kate Moss is still a supporter of charity organizations and uses her position and power for the benefit of society. Her efforts to give back to society and effect positive change are in line with her humanitarian pursuits.

5. Adopting Honesty and Transparency:

Kate Moss has embraced candor and honesty in the twenty-first century and beyond. She can establish a deeper personal connection with her audience by being open and honest about her struggles and experiences. Her continued candor is a reflection of her complex and dynamic personality.

Kate Moss's lasting legacy bears witness to her ageless effect on beauty and fashion. She is more than just a supermodel; she is a representation of uniqueness, authenticity, and the "Moss Effect," which is still reshaping the worlds of beauty and fashion. Those who value her extraordinary career, her enduring influence,

and her capacity to continue driving positive change in the business and beyond find inspiration in her legacy.

8.2 Influence on Future Generations

Kate Moss's influence on the beauty and fashion industries goes beyond her period. Future generations of models, designers, and fashion fans will continue to be influenced and inspired by her legacy.

1. An Icon of Timeless Style:

The everlasting nature of Kate Moss's influence is among its most notable features. Fashionistas of all ages continue to be drawn to her trademark style, which combines a rock 'n' roll attitude with boho elegance. Her uniqueness and genuineness act as a benchmark for many who look up to her.

Kate Moss is a style icon whose impact transcends the boundaries of her time. Her timeless appeal is demonstrated by her ability to change and modify her style in response to shifting fashion trends. Because of

her versatility, she can continue to serve as an inspiration to up-and-coming designers as well as established ones.

2. Developing Upcoming Models:

Kate Moss's devotion to influencing the next generation is demonstrated by her role as a mentor to emerging models. Her experiences and expertise are priceless for individuals hoping to pursue careers similar to hers. Her mentoring helps up-and-coming talent in the fashion business grow and flourish.

In addition to her legendary reputation, Kate Moss is admired by upcoming models for her genuineness and fortitude in overcoming the challenges of the fashion industry. Those starting their modeling careers can draw inspiration from her resilience and ability to stay influential.

3. Changing Commercial Attempts:

Aspiring designers and fashion entrepreneurs might draw inspiration from Kate Moss's forays into commerce and entrepreneurship. Her prosperous initiatives into fashion collections, fragrances, and other endeavors show how the sector can be diversified.

For others in the future hoping to establish themselves in the fashion and beauty industries, Kate Moss's skill as a businesswoman in balancing originality with commercial viability serves as an inspiration.

4. Dedication to Philanthropy:

Kate Moss's commitment to charitable work serves as a reminder of the good deeds one may do for society. Her commitment to charity organizations serves as an example of how important it is to use one's position and power for the benefit of society. For individuals who want to change the world, this dedication to giving back serves as inspiration.

5. A Durable Heritage:

One of the main components of Kate Moss's lasting legacy is her impact on upcoming generations. Her influence transcends time and continues to mold and uplift others who look up to her for direction and inspiration. Her effect serves as a reminder that tenacity, individuality, and honesty are timeless traits that can have a lasting impact on the fashion and beauty industries.

CONCLUSION

Kate Moss is a brilliant star in the worlds of fashion, beauty, and influence; her influence extends well beyond the catwalk. Her incredible path from a young child growing up in Croydon, England, to becoming a well-known supermodel around the world is proof of her brilliance, enduring appeal, and significant influence.

In a field where standards of beauty had long been set, Kate Moss's career upended preconceived notions of beauty. Her unusual features and androgynous charm defied convention, demonstrating the limitlessness of true beauty. She personified the "heroin chic" movement, which signaled a move away from the refined, Photoshopped pictures of the past and toward genuineness and unadulterated beauty.

However, Kate Moss is more than just a model; she is a muse who brought forth some of the most famous moments in fashion history for well-known designers

and photographers. Her partnerships with Vivienne Westwood, Alexander McQueen, and John Galliano produced ground-breaking collections and advertising campaigns. Her impact could be seen in popular culture, music, and art, as she rose to prominence as a representation of uniqueness and honesty.

Even after years of public attention, Kate Moss has handled difficulties with poise and fortitude. Her capacity to move past scandals and keep her influence is a testament to her enduring appeal and the public's interest in her. A major turning point in her life was becoming a mother, which demonstrated her capacity to manage both her personal and professional obligations.

The enduring impact of Kate Moss is evidence of her versatility, ageless style, and multifaceted career. As a mentor, she imparts her skills and experiences to help the upcoming generation of models. Her pursuit of humanitarian and business enterprises exemplifies her entrepreneurial drive and dedication to contributing to society.

The impact of Kate Moss extends beyond her period, influencing upcoming cohorts of fashion aficionados, designers, and models. Her capacity to continue inspiring people highlights her significant and ongoing influence on the beauty and fashion industries.

Kate Moss is ultimately more than simply a supermodel; she is a representation of uniqueness, authenticity, and the revolutionary "Moss Effect," which keeps redefining influence, fashion, and beauty. Her story inspires everyone, showing us that genuine beauty comes from accepting our individuality and being who we are without apology. A constant symbol and living legend, Kate Moss has a profound influence on the fashion and beauty industries.

Printed in Great Britain
by Amazon

36268786R00050